# "IT'S NOT JUST DARK IN SCANDINAVIA."

BO BRENNAN

# INSTA GRAMMAR
# NORDIC

LANNOO

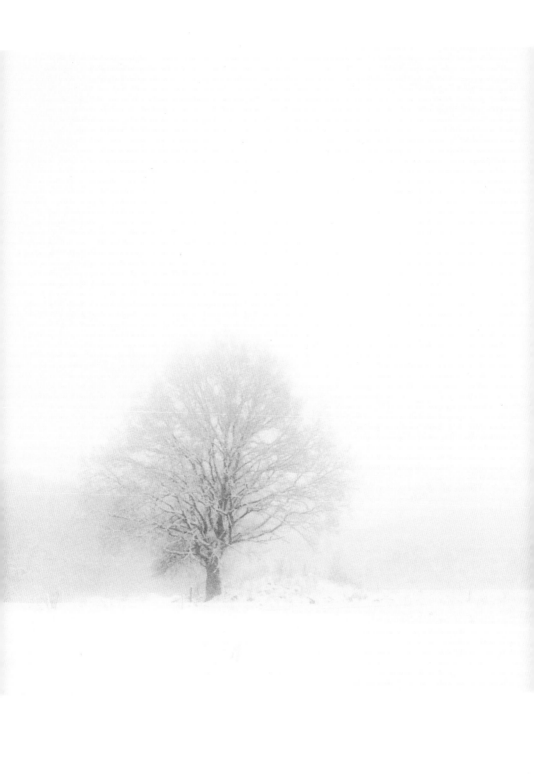

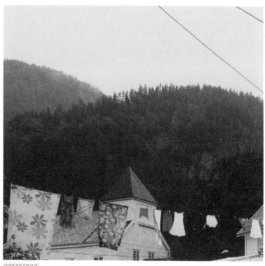
@IRENEFINNE

@IRENEFINNE

@IRENEFINNE

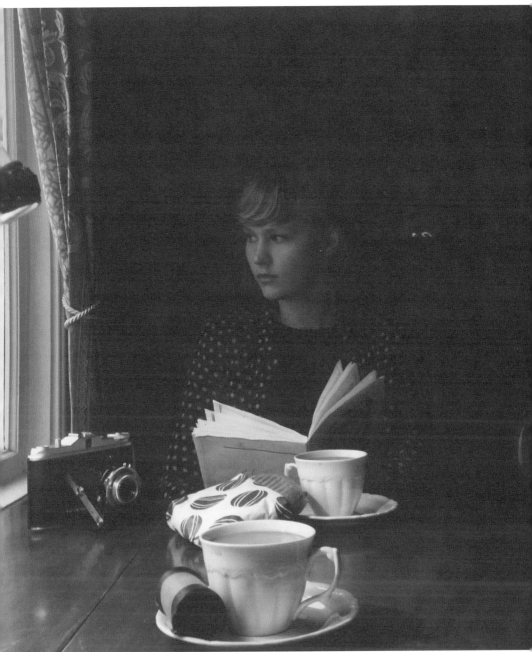

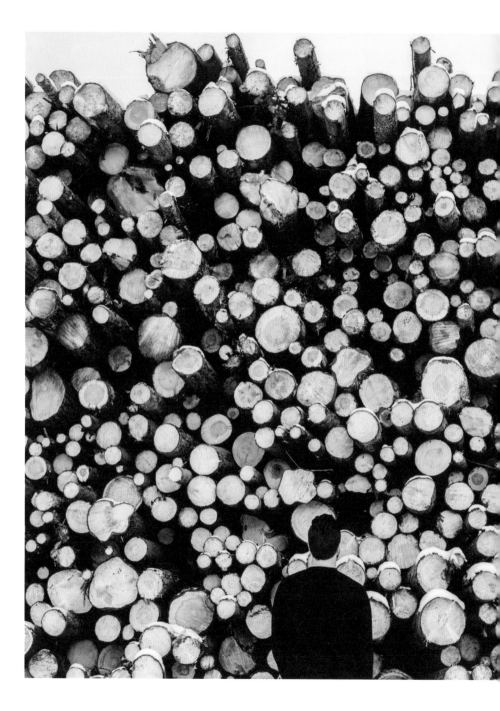

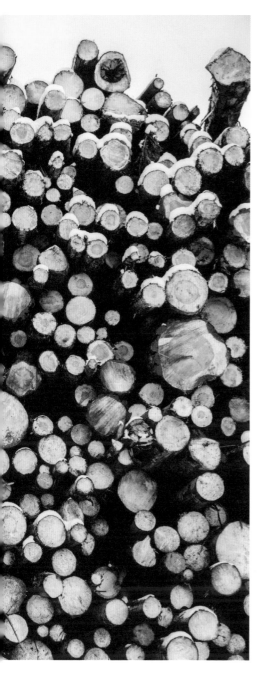

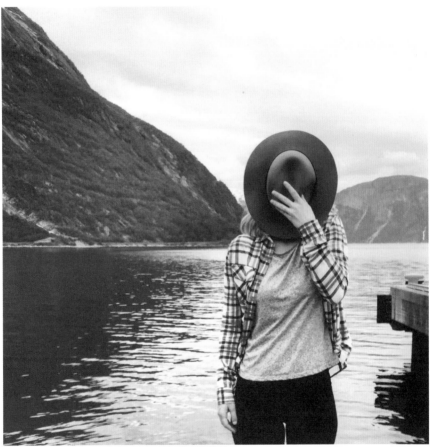

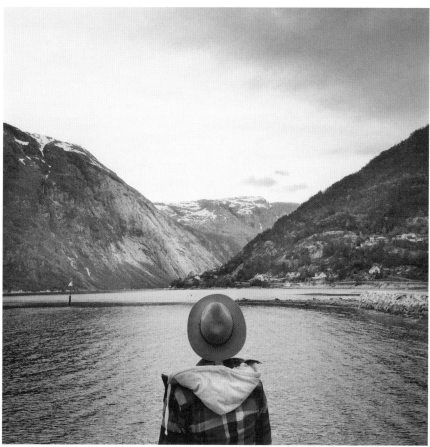

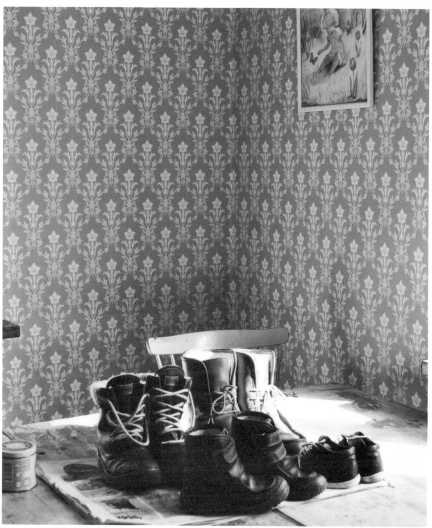
@FLICKANOCHTANTEN

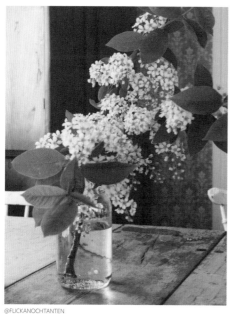

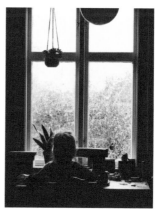

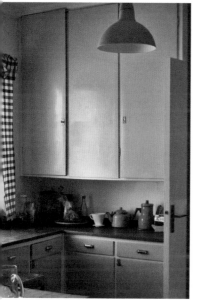

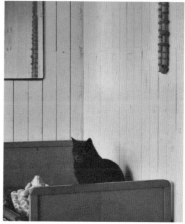

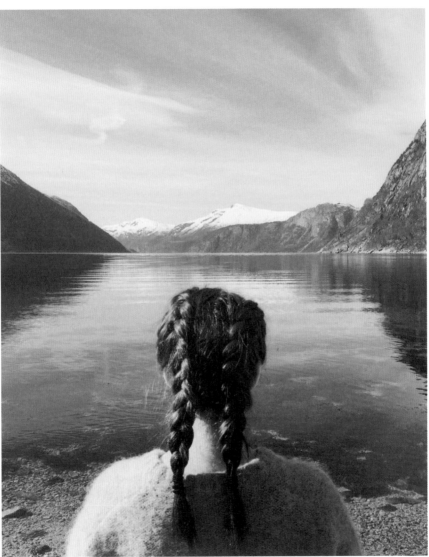

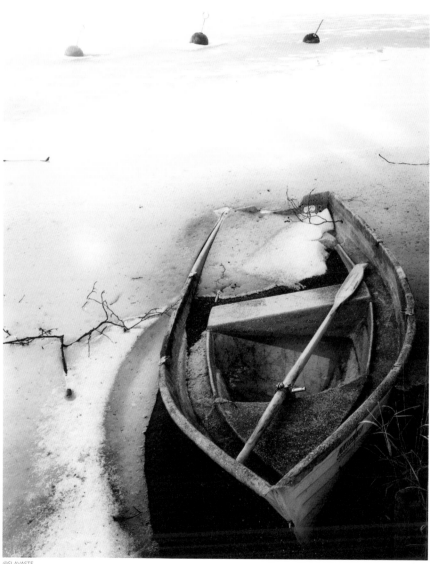

# "THERE'S SOMETHING I LOVE ABOUT HOW STARK THE CONTRAST IS BETWEEN JANUARY AND JUNE IN SWEDEN."

BILL SKARSGÅRD

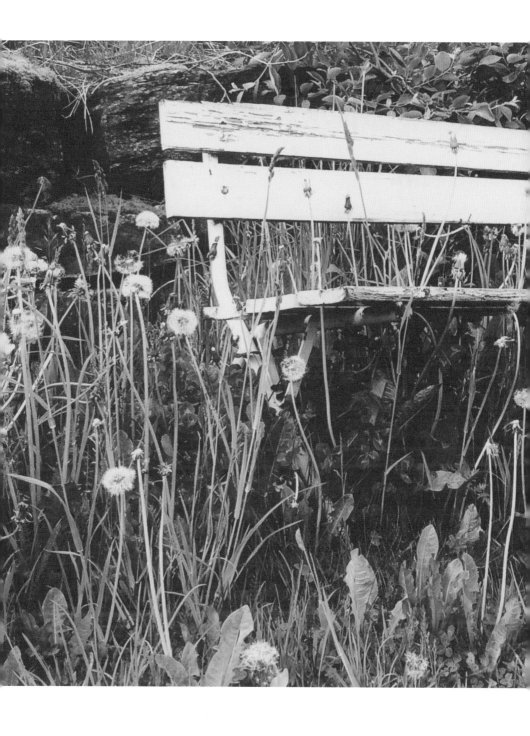

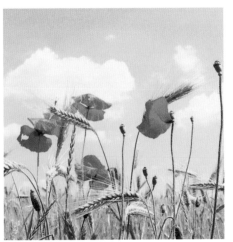
@MISAUNTE

@MISAUNTE

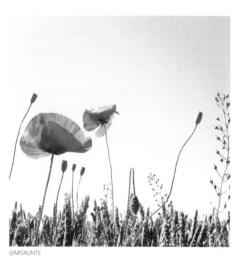

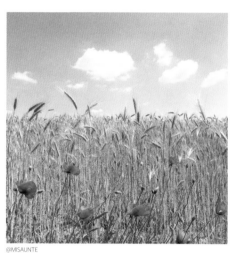

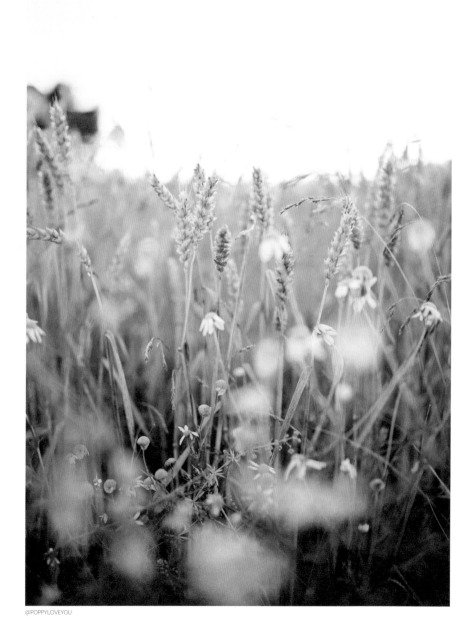

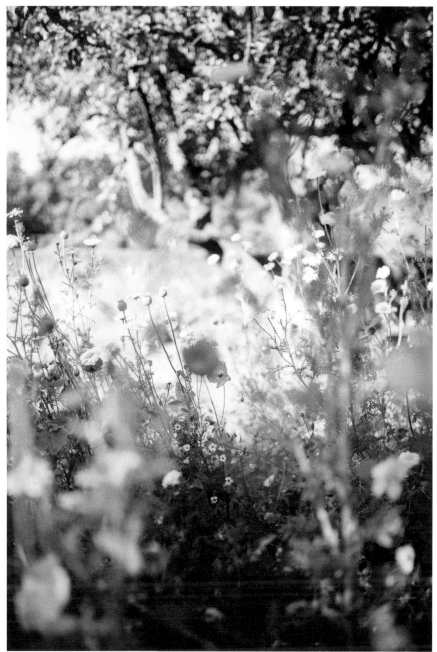

@SLAVASTE

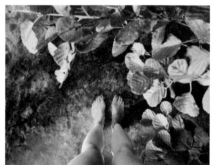

@SLAVASTE

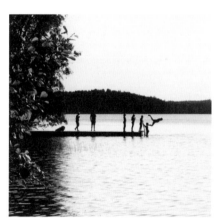

@SLAVASTE

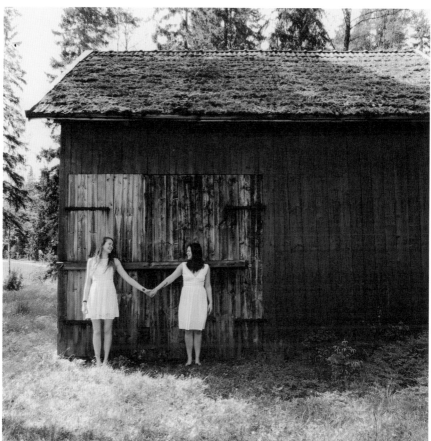

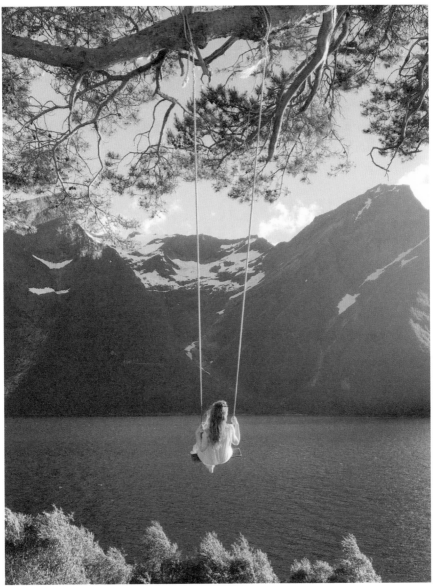

# "ON EARTH THERE IS NO HEAVEN, BUT THERE ARE PIECES OF IT."

JULES RENARD

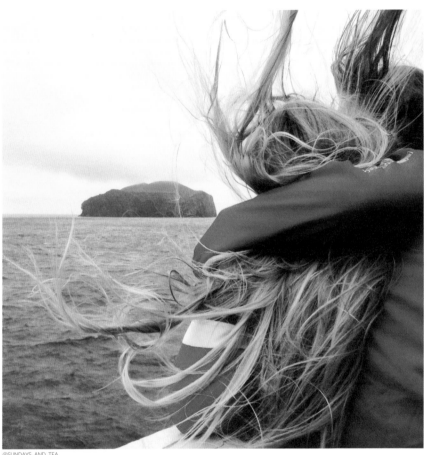

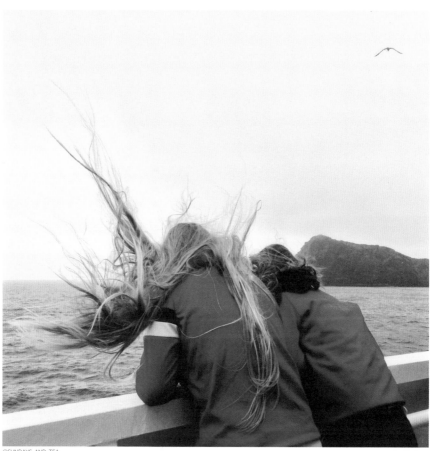

@SUNDAYS_AND_TEA

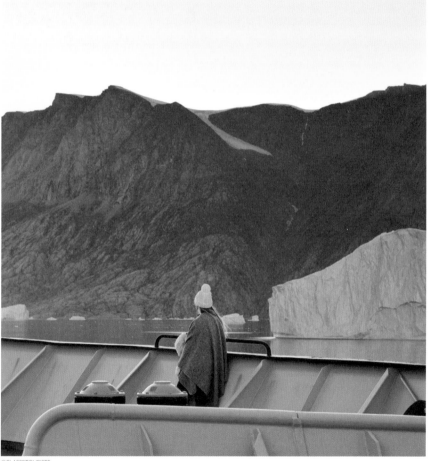

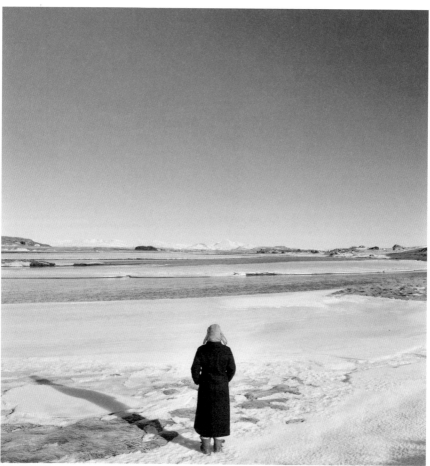

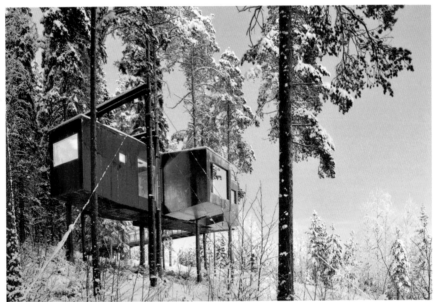

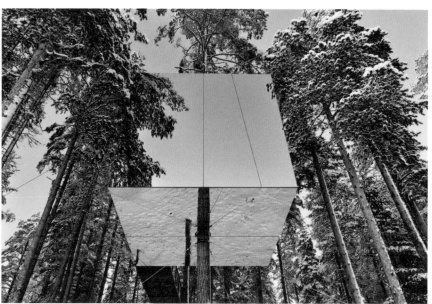

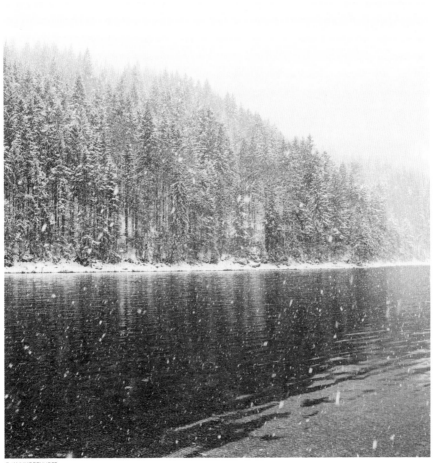

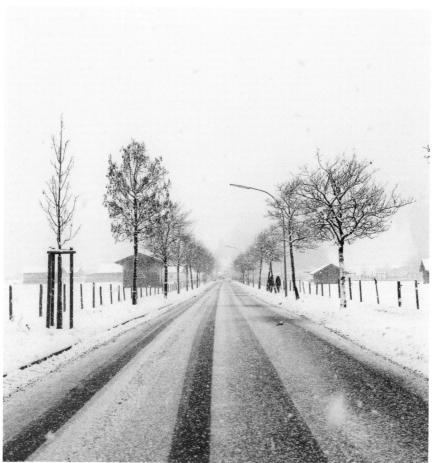

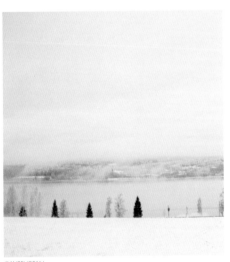

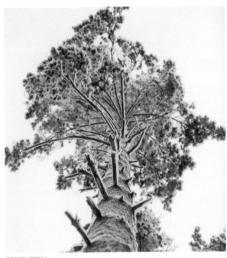

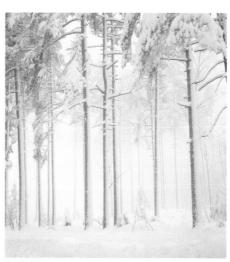

@TERHOM

@ANGELIQE.NU

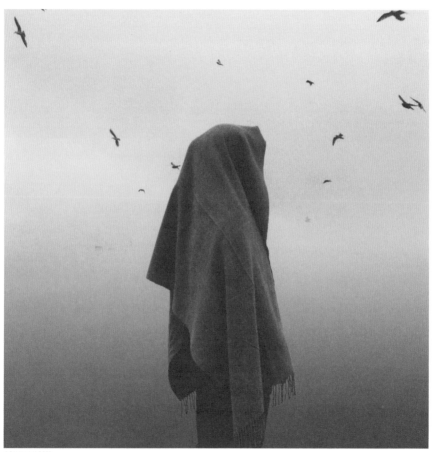

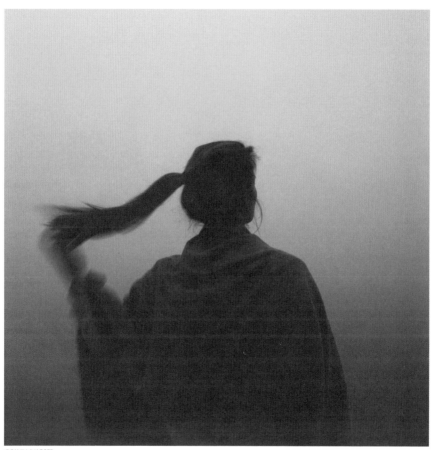

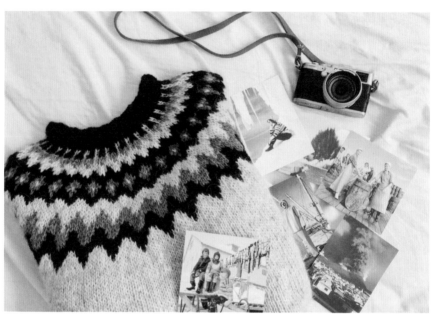

@SUNDAYS_AND_TEA

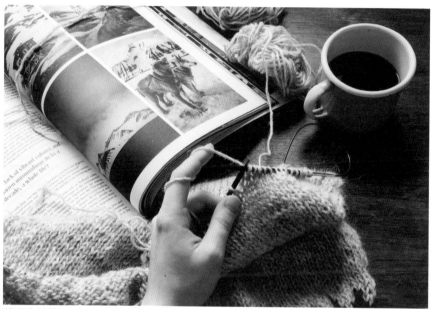

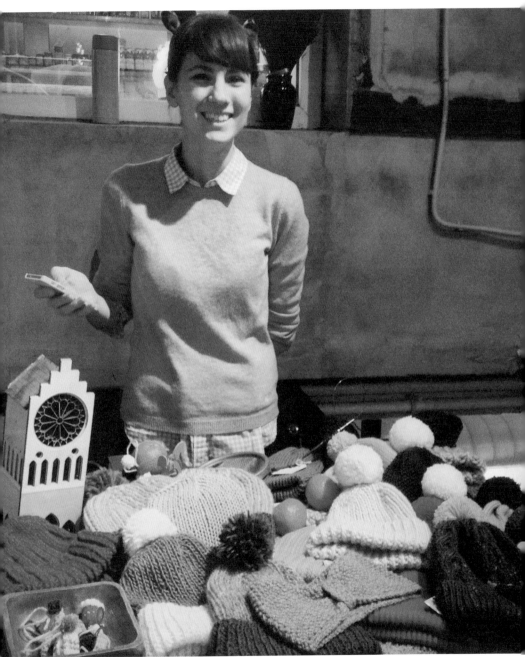

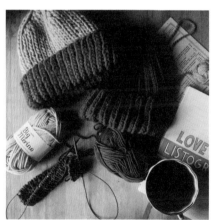

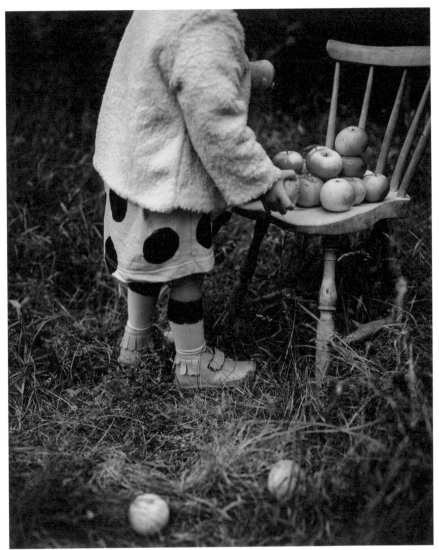

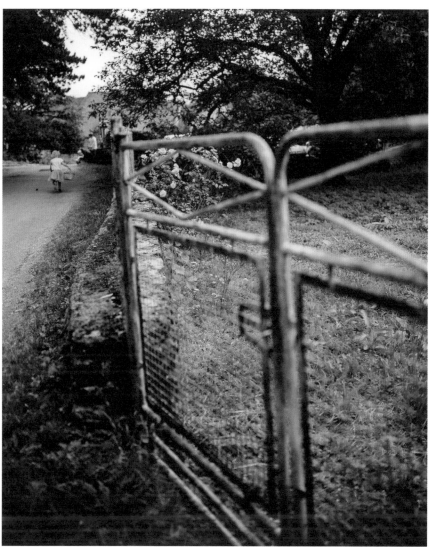

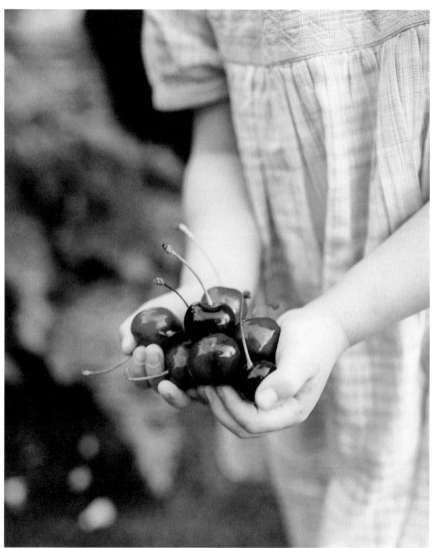

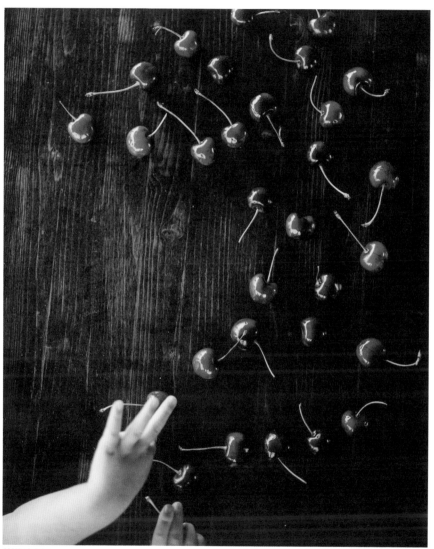

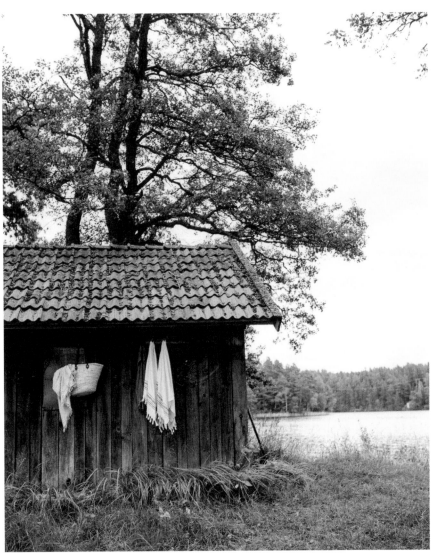

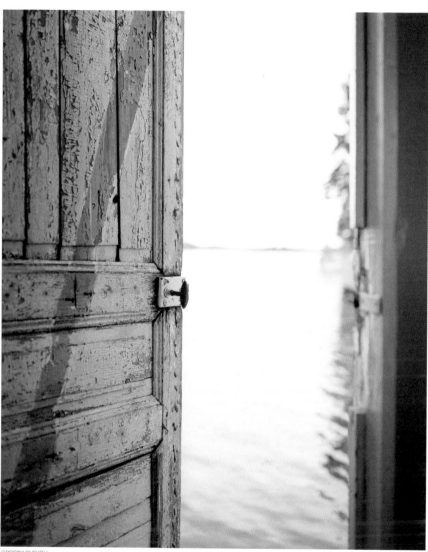

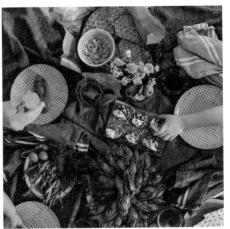

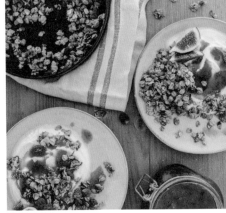

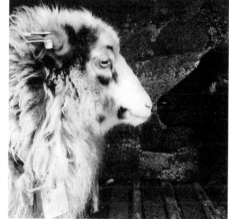

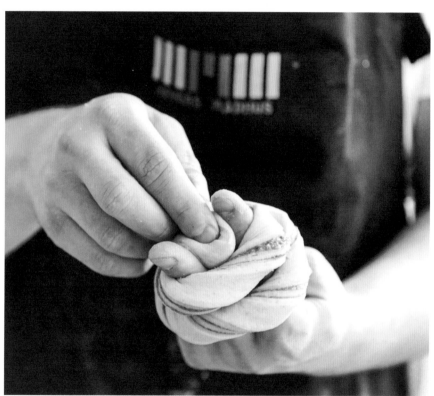
@MEYERSMAD picture by @schonnemann

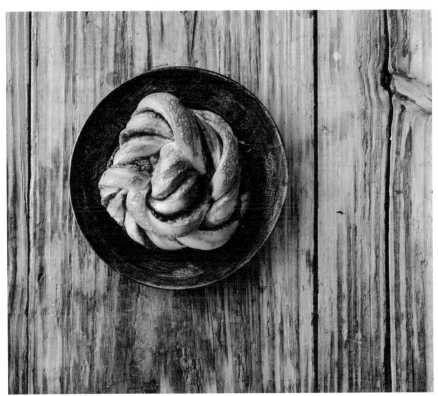

@MEYERSMAD picture by @schonnemann

@MEYERSMAD picture by @schonnemann

"EVEN THE
SMALLEST
OF STARS
SHINES IN THE
DARKNESS."

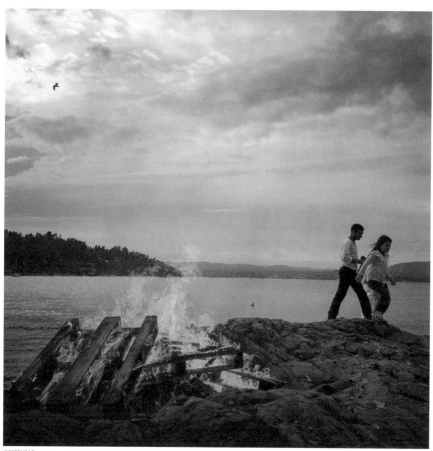

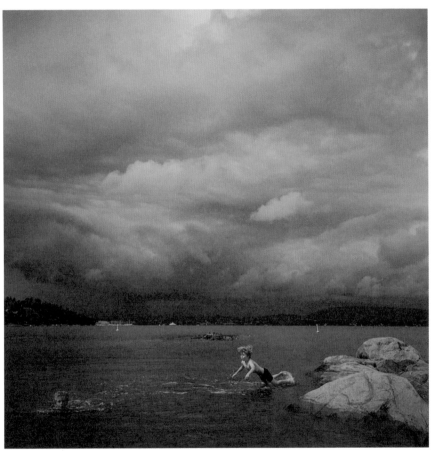

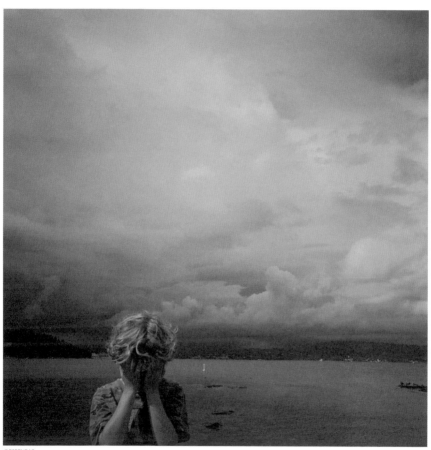

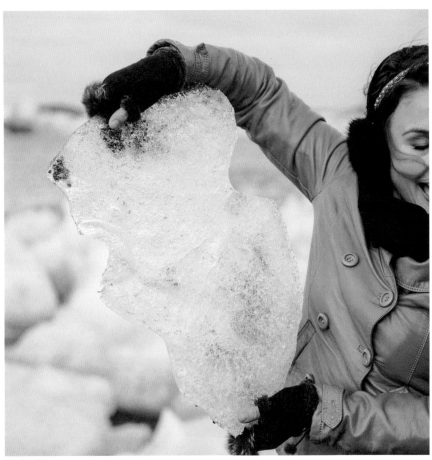

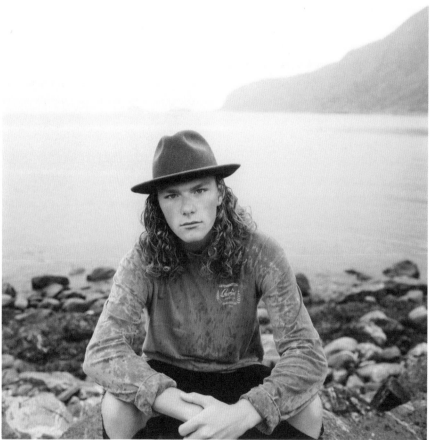

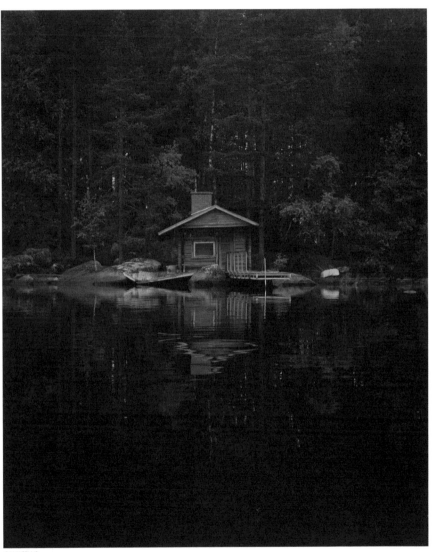

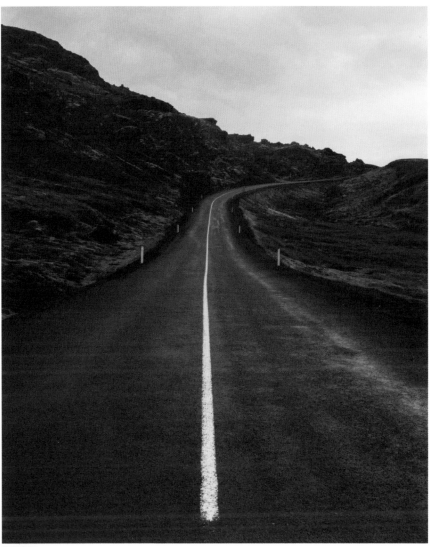

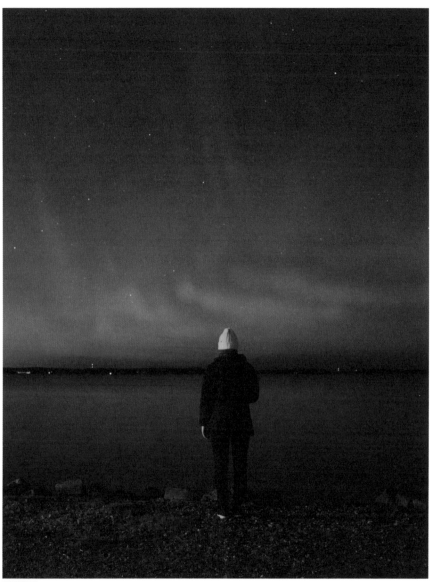

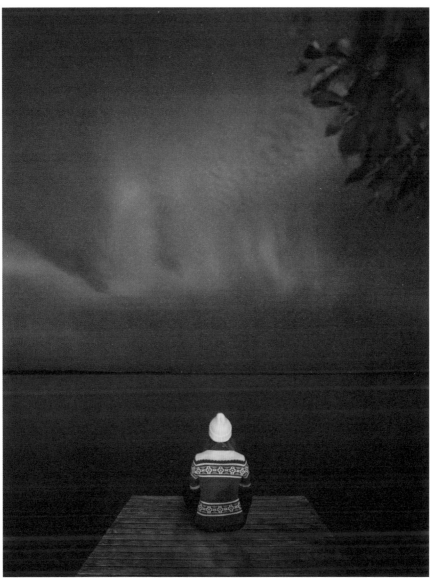

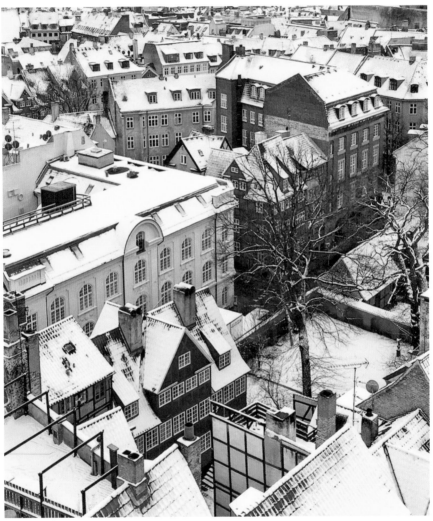

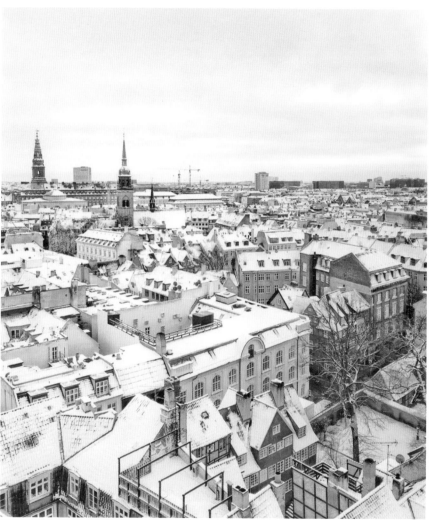

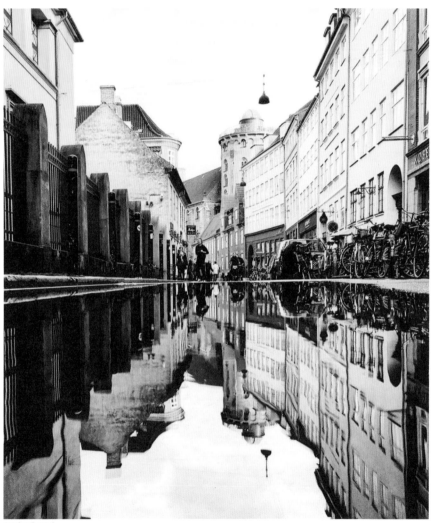

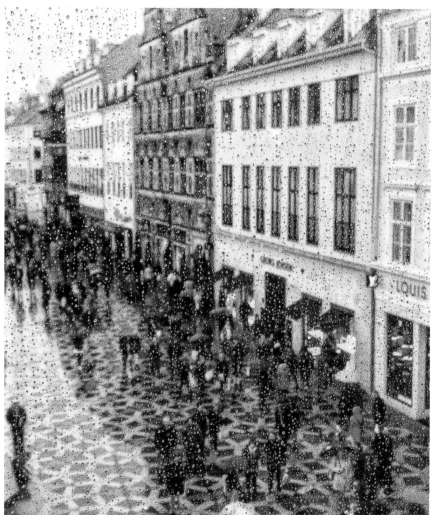

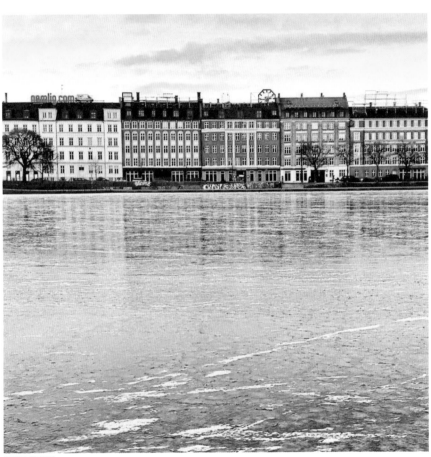

@NIKOLAJTHANING

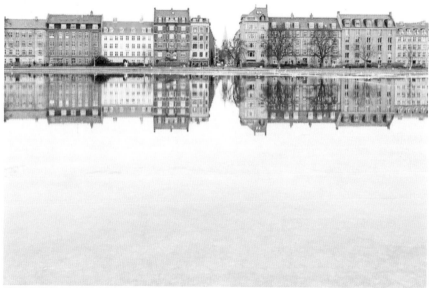

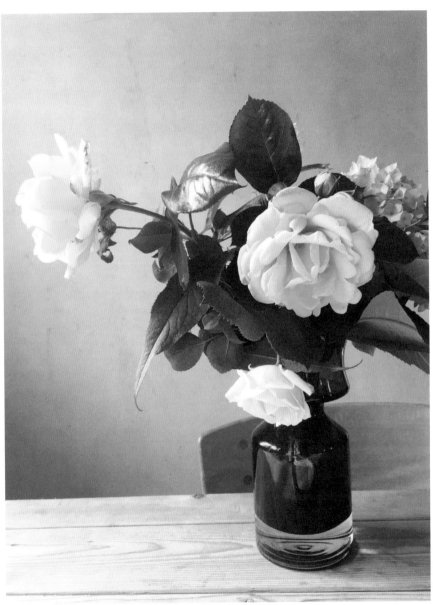

@METTEDUEDAHL

@METTEDUEDAHL

@TERESE_K

@LEKESTOVE

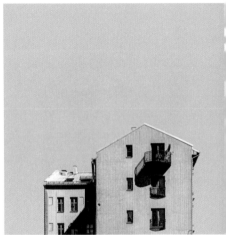

@LEKESTOVE

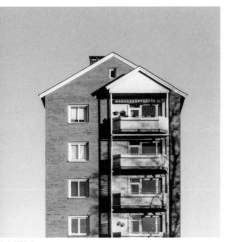

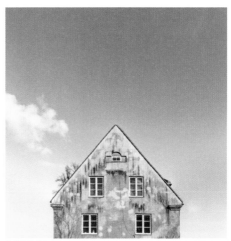

# "WINTER WONDERLAND IS ON MY HAND, IT'S KINDA ROCKY"

NICKI MINAJ

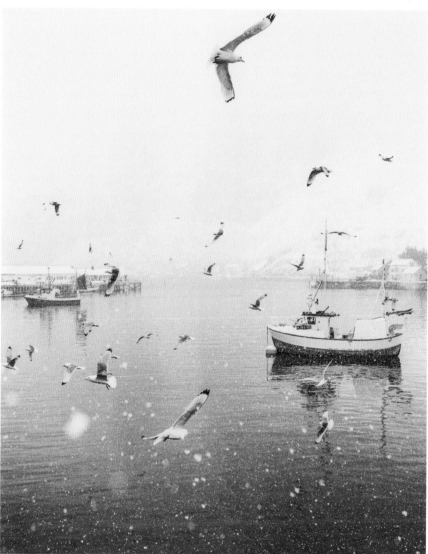

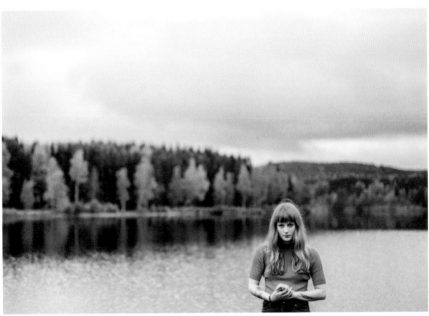

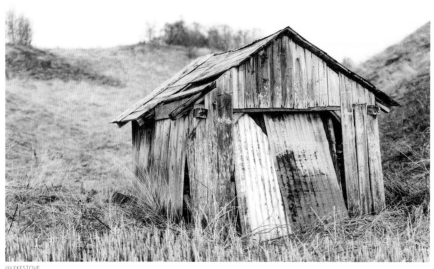

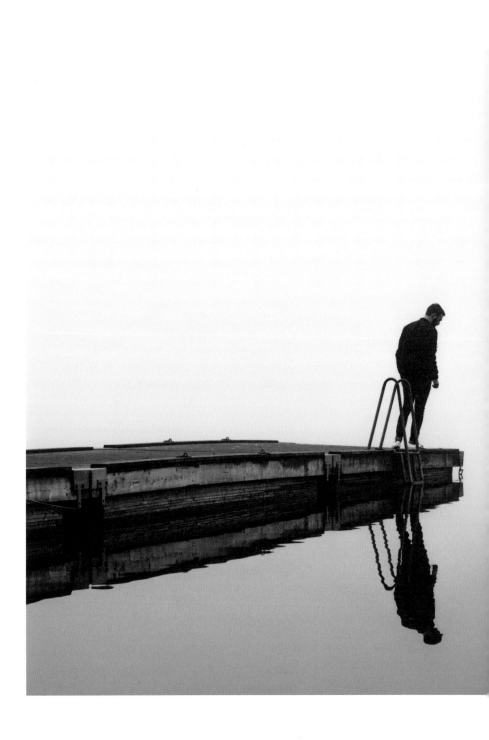

# "DENMARK IS A SMALL PLACE

MADS MIKKELSEN

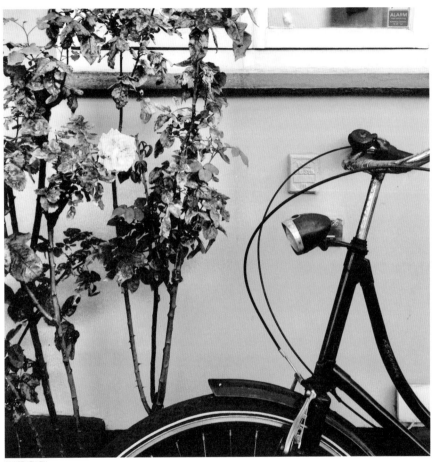

@LINETHITKLEIN

# WE ALL KNOW EACH OTHER."

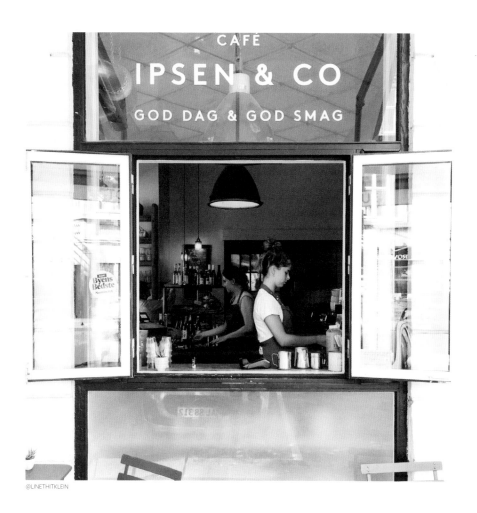

@KRISTINENOR

@KRISTINENOR

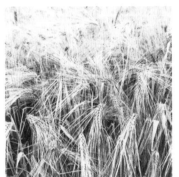
@KRISTINENOR

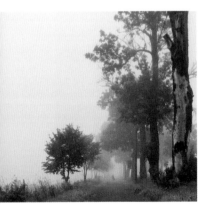
@KRISTINENOR

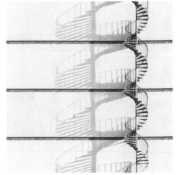
@KRISTINENOR

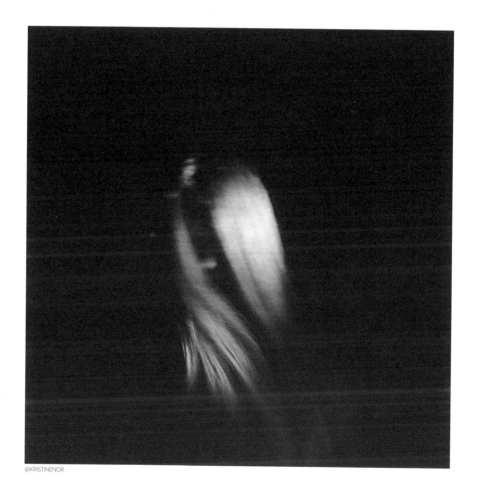

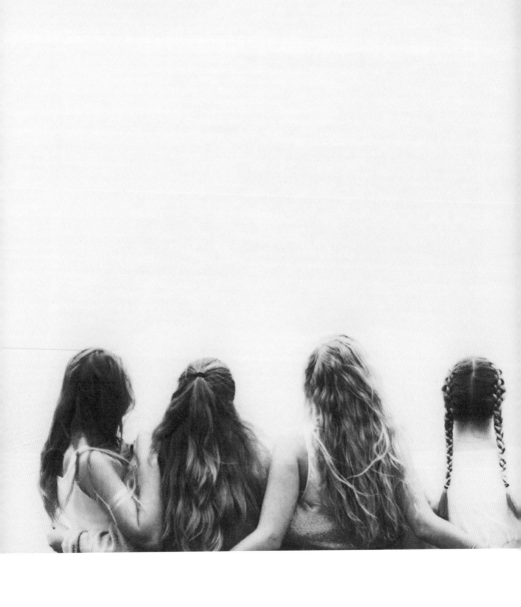

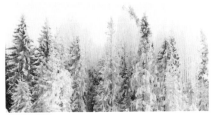

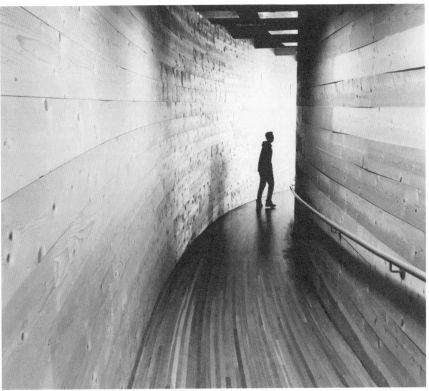

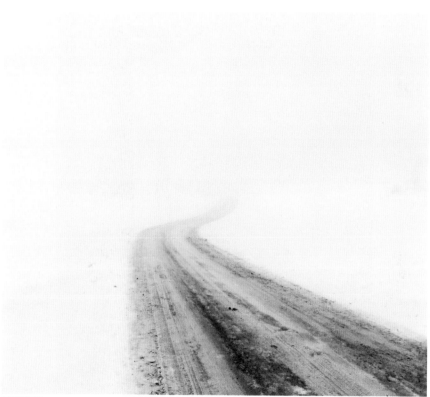

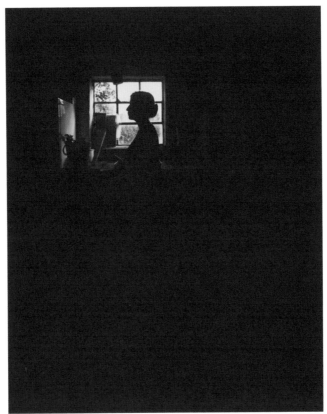

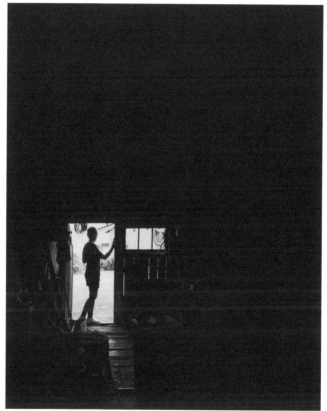

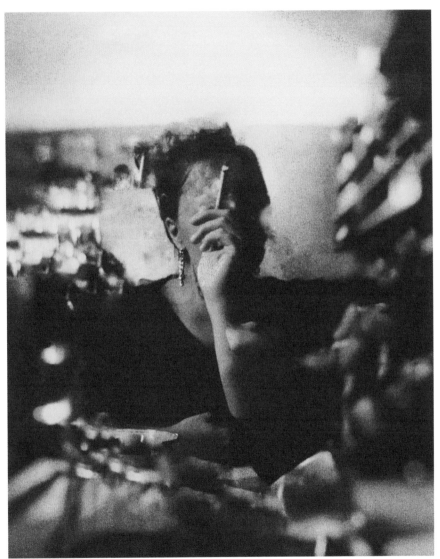

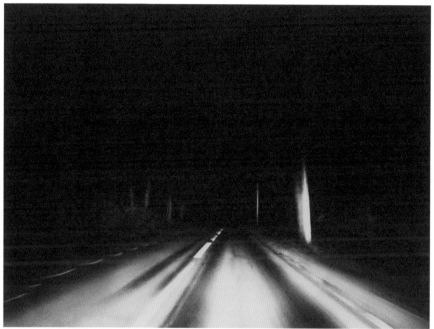

# "AUTUMN ARRIVES IN EARLY MORNING, BUT SPRING AT THE CLOSE OF A WINTER DAY."

ELIZABETH BOWEN

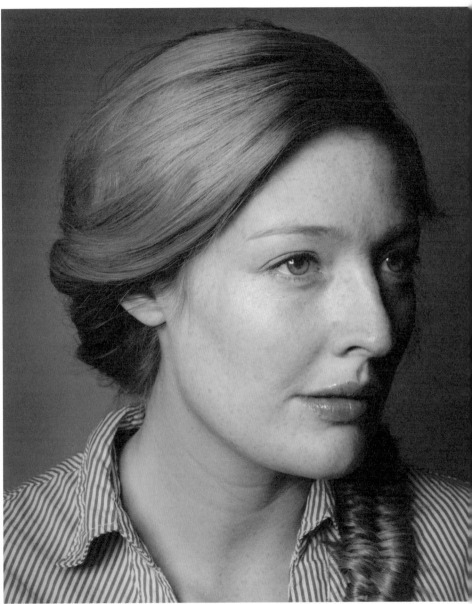

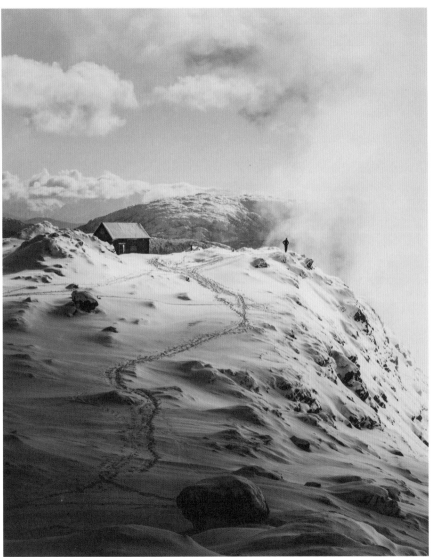

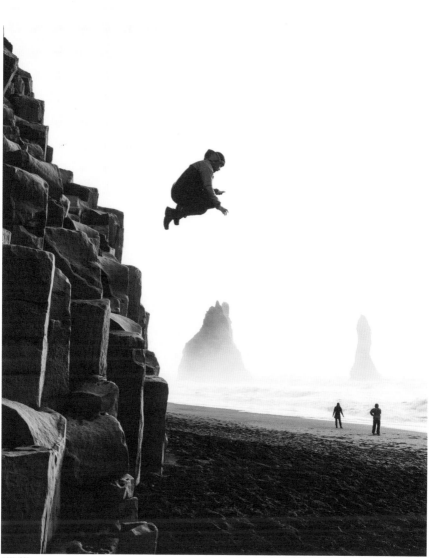

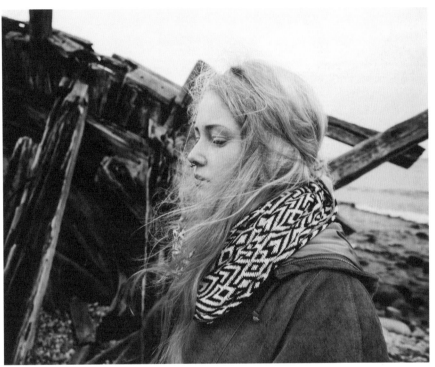

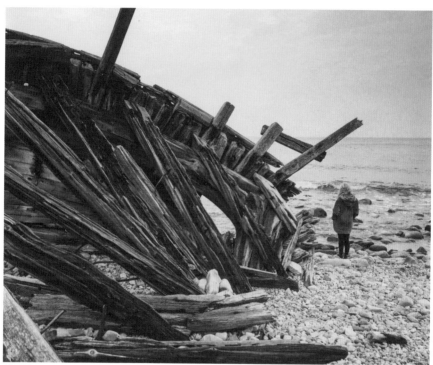

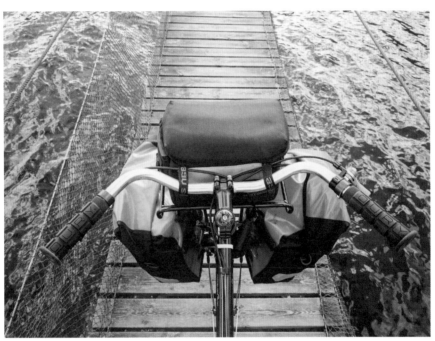

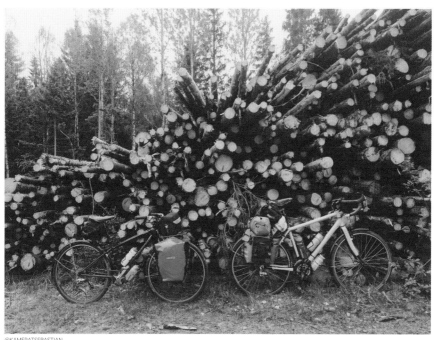

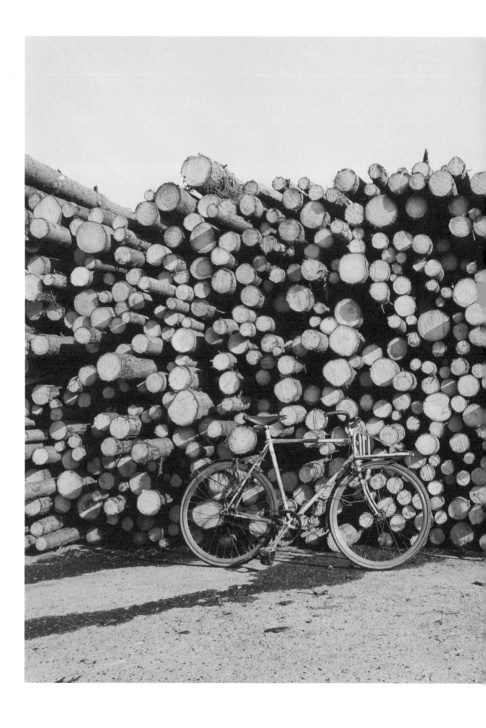

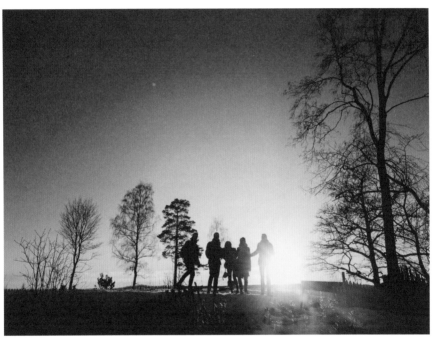

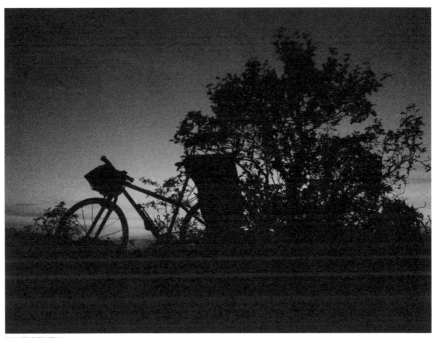

@ANNETTEPEHRSSON

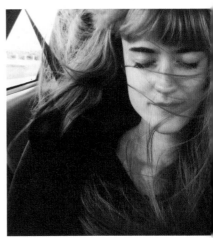

@ANNETTEPEHRSSON

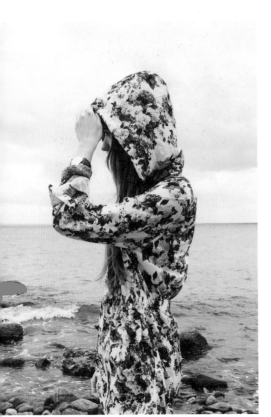

@ANNETTEPEHRSSON

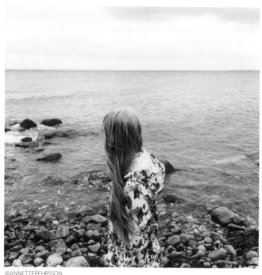

@ANNETTEPEHRSSON

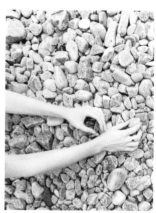

@ANNETTEPEHRSSON

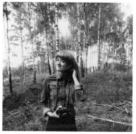

@ANNETTEPEHRSSON

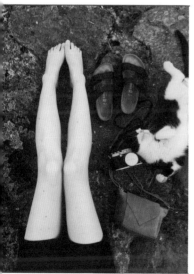

@ANNETTEPEHRSSON

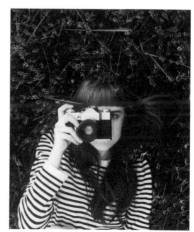

@ANNETTEPEHRSSON

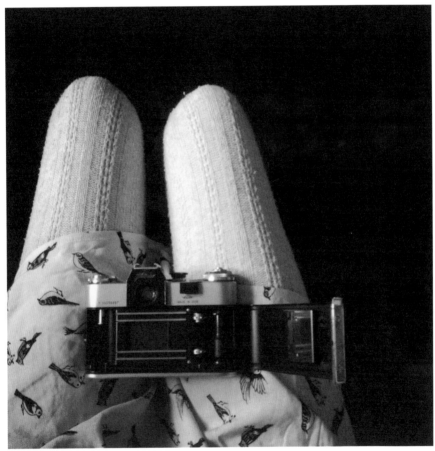

@ANNETTEPEHRSSON

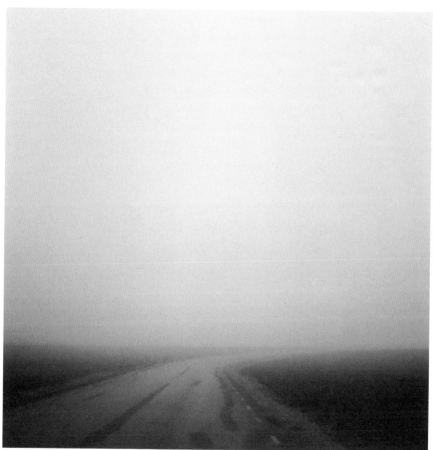

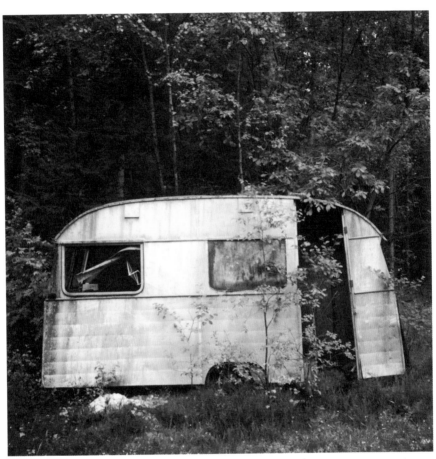

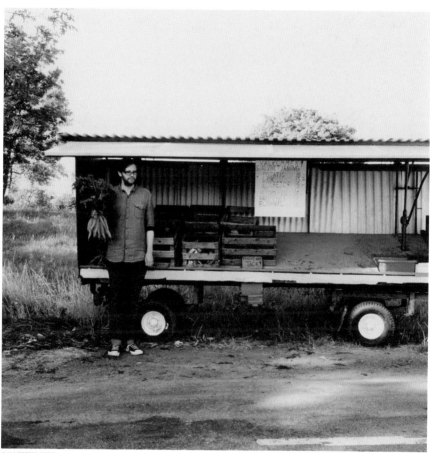

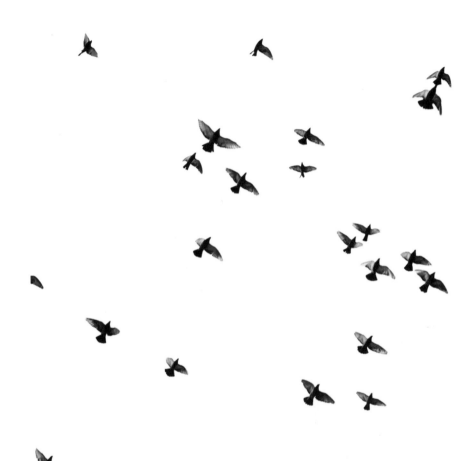

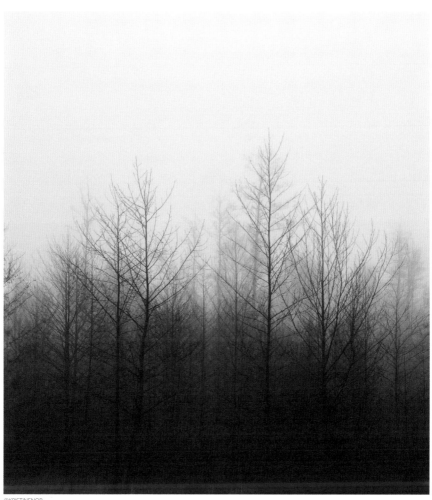

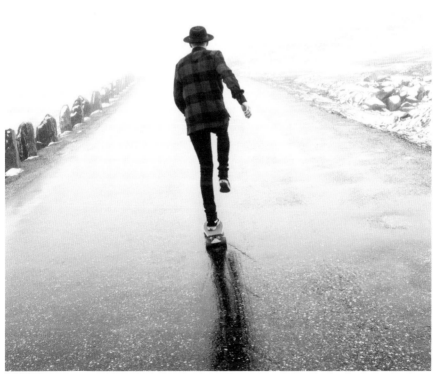

www.lannoo.com
Register on our website for our newsletter with
new publications as well as exclusive offers.

Photo Selection/Book Design:
Irene Schampaert

Cover image:
@angeliqe.nu

Also available:
Insta Grammar Cats
Insta Grammar City

If you have any questions or remarks, please contact
our editorial team: redactiekunstenstijl@lannoo.com.

© Uitgeverij Lannoo nv, Tielt, 2016
D/2016/45/256 – NUR 652/653
ISBN 9789401436946